WHY UNICORN DRINKS

This is dedicated to everyone who has ever felt alone, and Joey, my friend who doesn't exist.

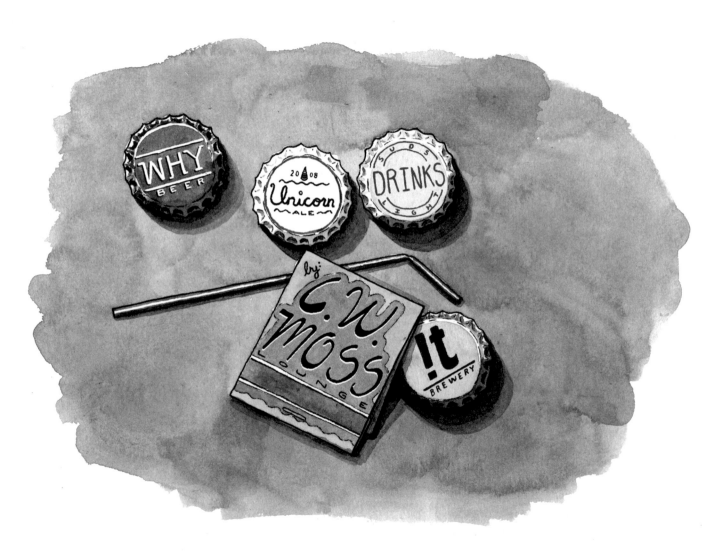

Because:

His stupid blonde, gay, dead baby, nerd, geezer, porch monkey, midget, cripple, blind guy, molesting, dune coon friends never laugh at his jokes.

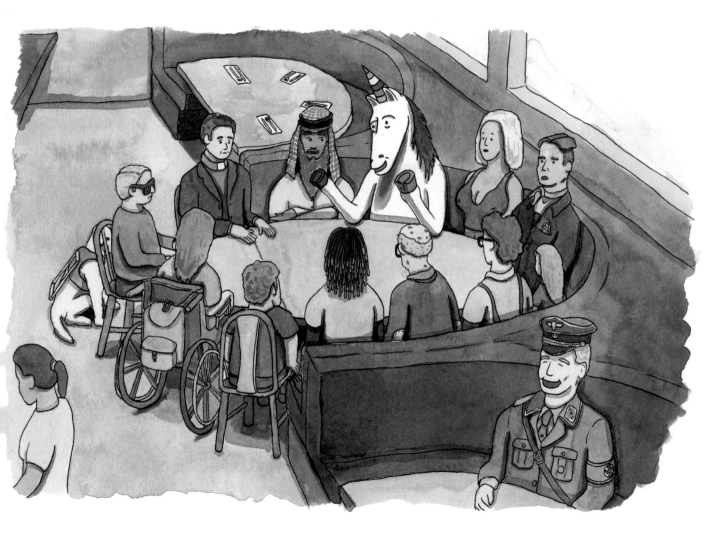

Strangers keep making fun of his tattoo of a fad culture.

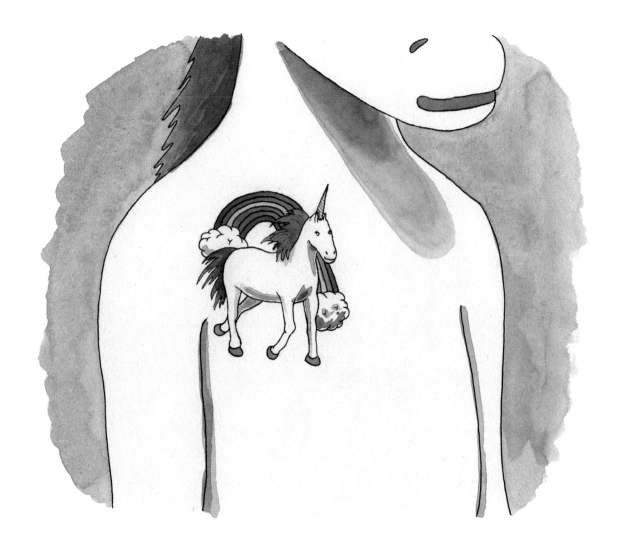

He thought it was the only way to top the country music charts.

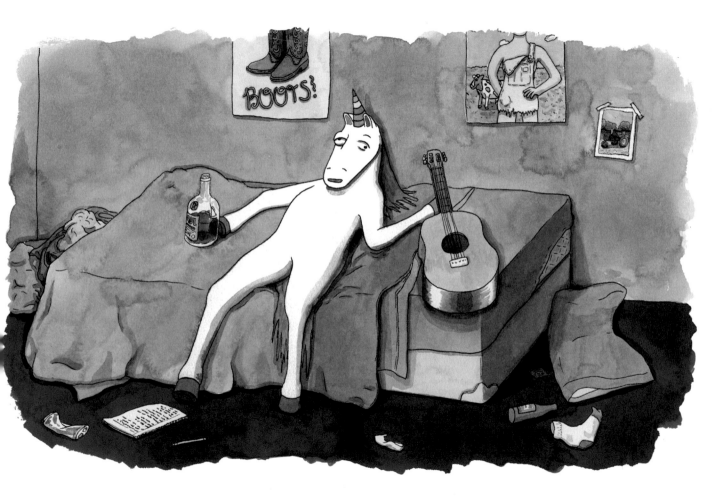

His first kiss was with his cousin.

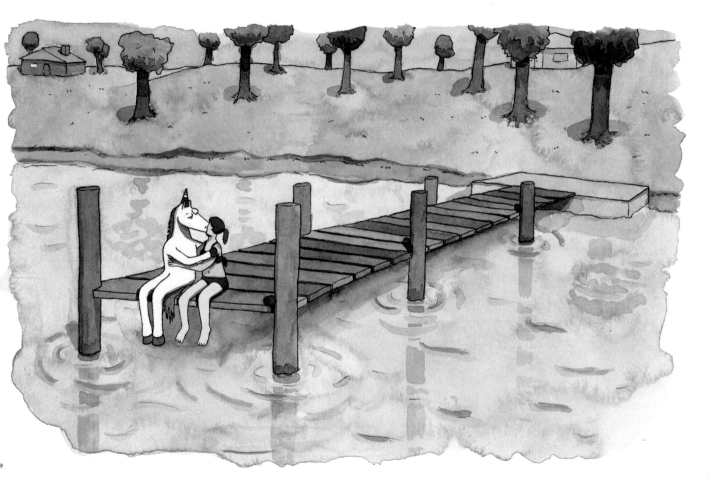

He can never open childproof bottles.

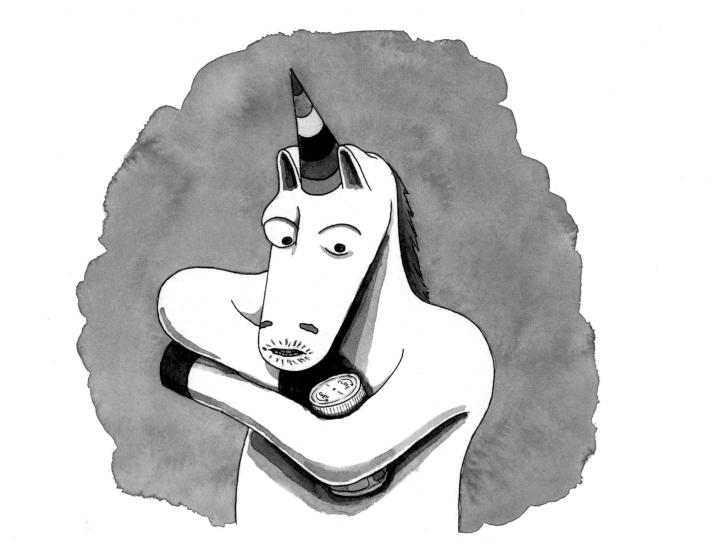

The internet is down and the VCR ate the only porn in the house.

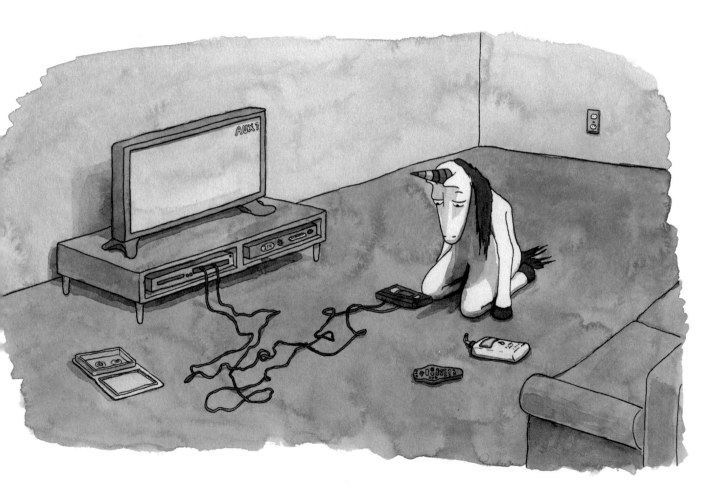

He can't eat at his favorite restaurant anymore because he tripped and impaled "one measly kid."

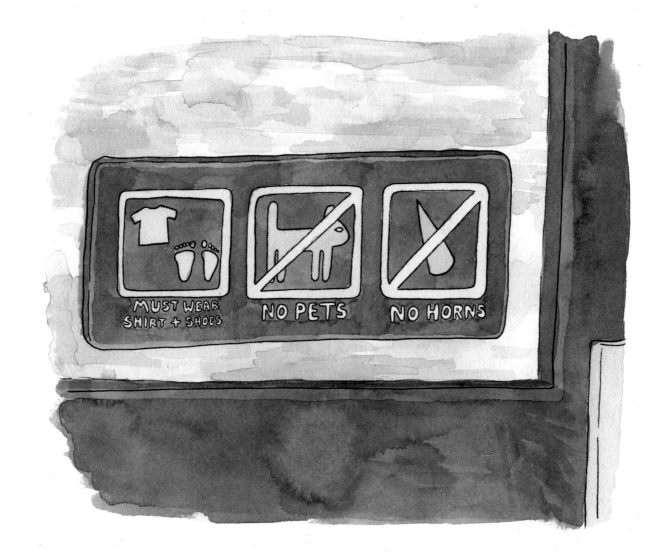

He never gets compliments on his beard.

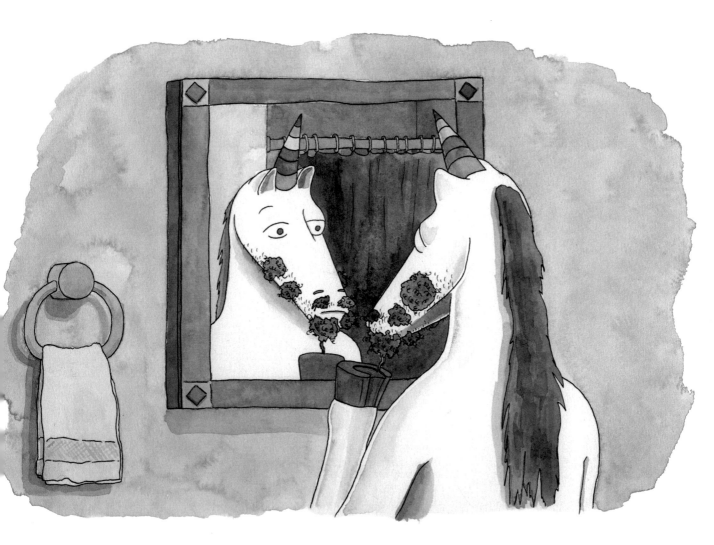

He thinks it's his fault his parents got a divorce.

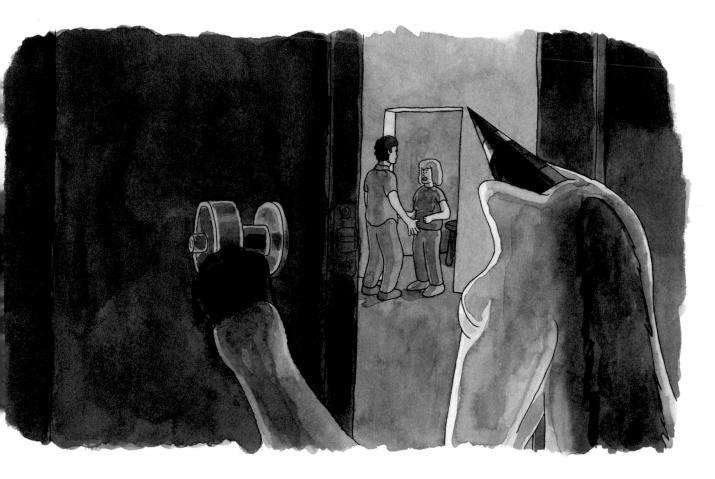

His never turns out like the one on the box.

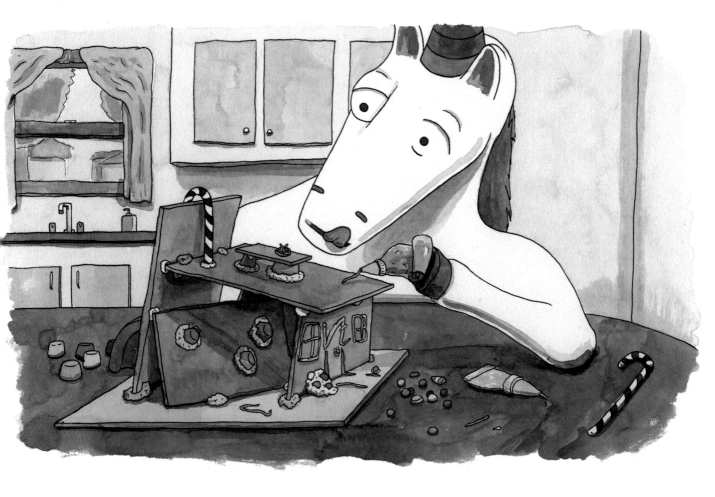

People think he is a carnival game.

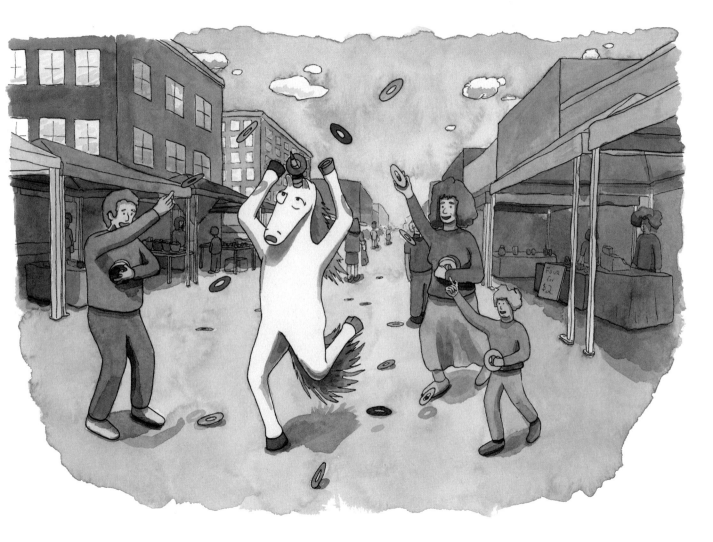

Marijuana isn't legal yet.

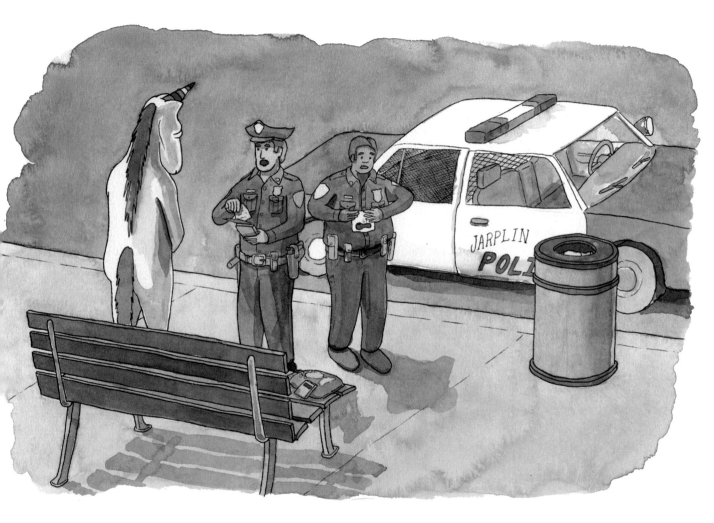

The position of 'town drunk' was available.

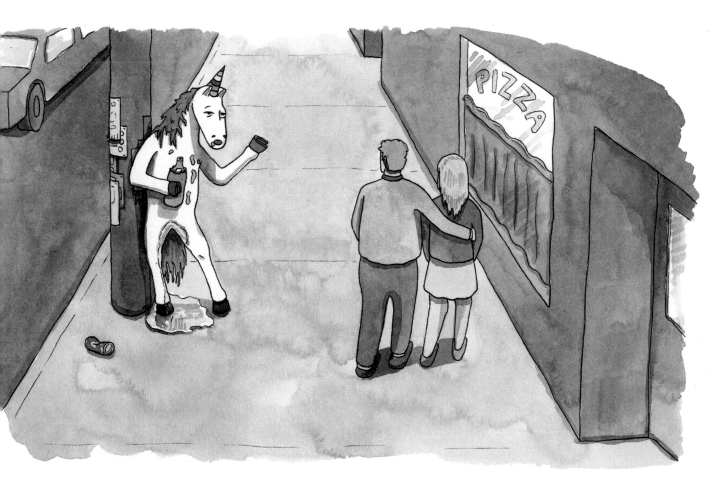

The cowboy raped him.

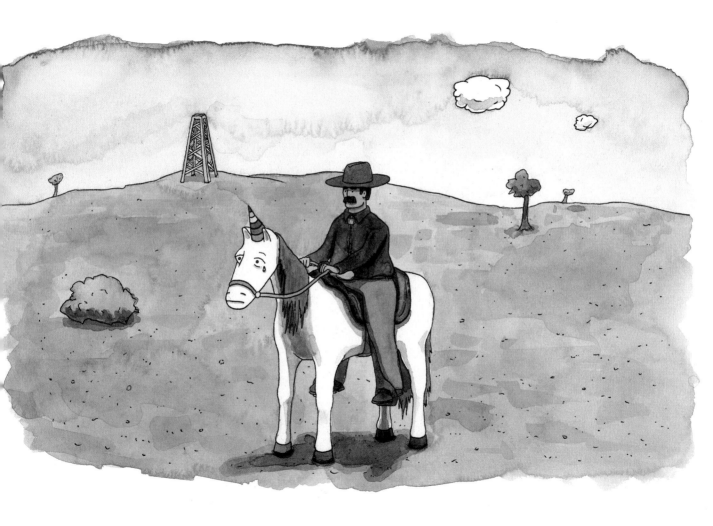

His wife doesn't care that he is allergic to cats.

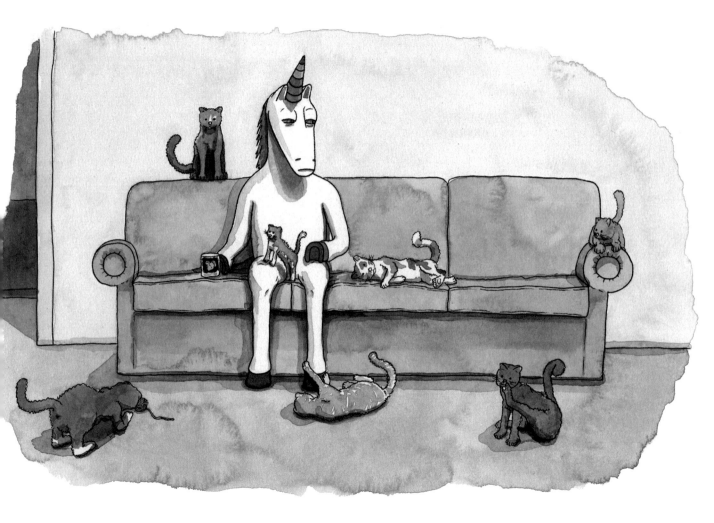

His last name won't be passed on.

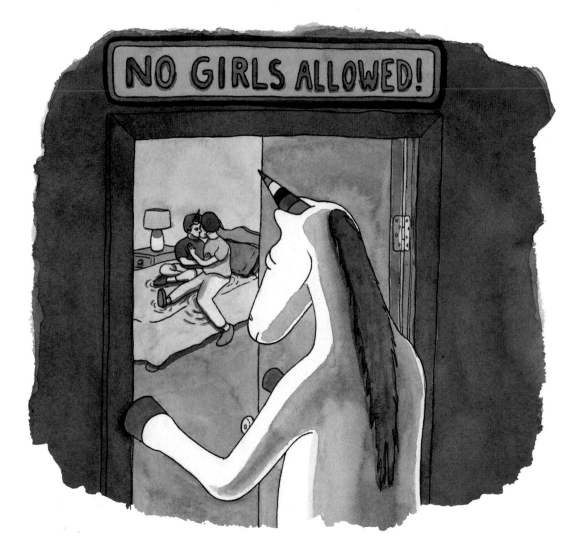

Everyone thinks clarinets are for pussies.

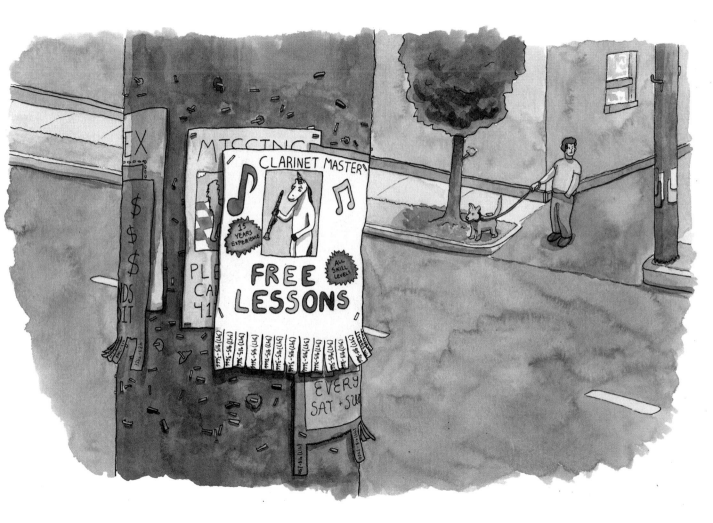

It's spring break, mother fucker!

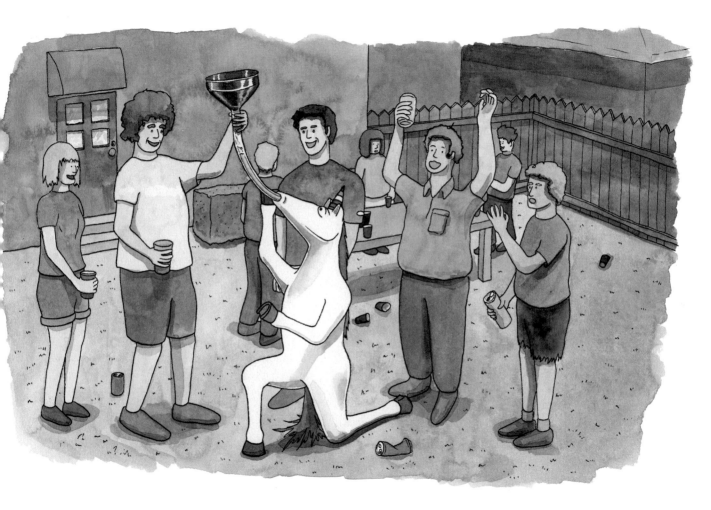

His stools are bloody and he thinks he is going to die.

Everyone ignores his protests at the Kentucky Derby™.

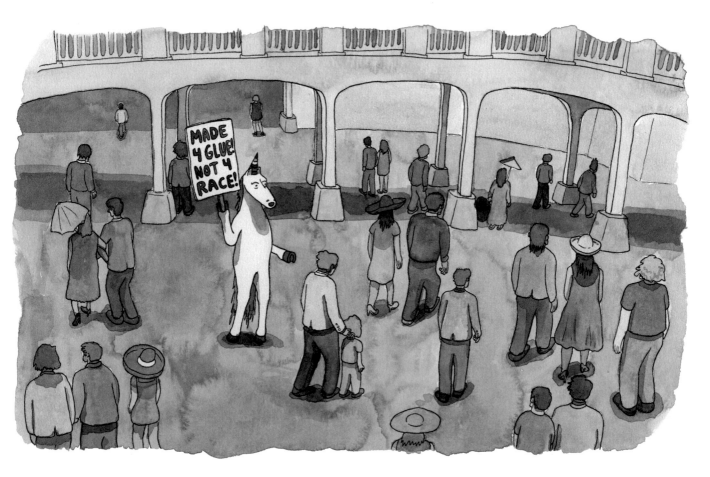

It was a girl.

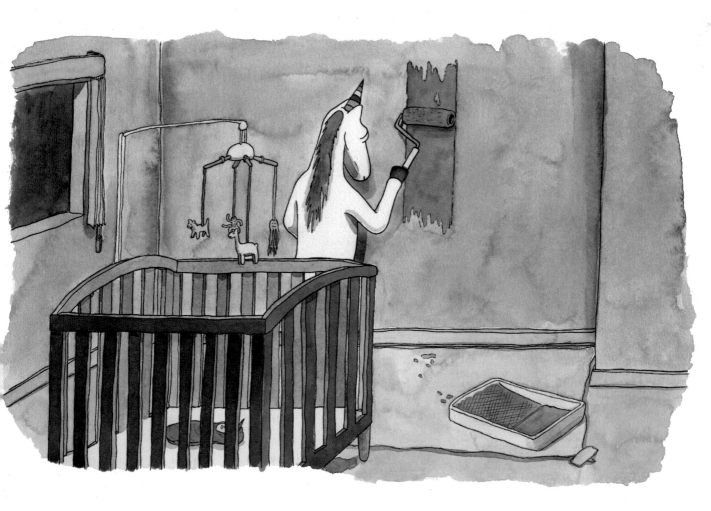

He had a bad dream where he clicked a link on the internet, and somehow ended up dead in outerspace.

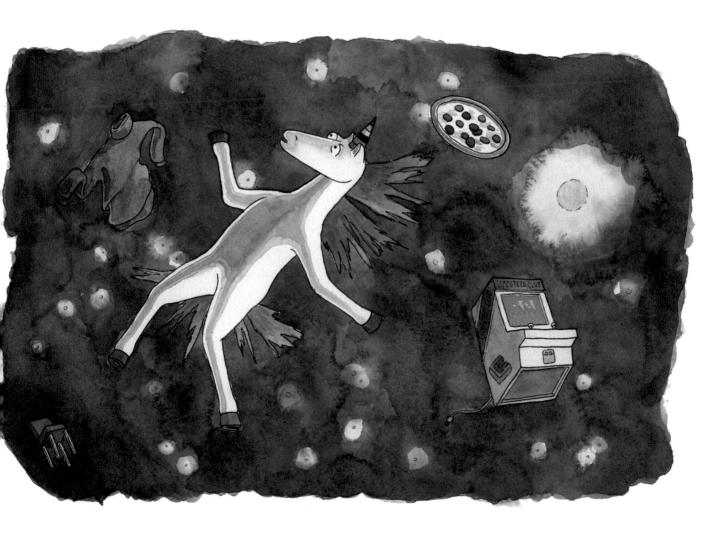

He overreacted to a joke about him.

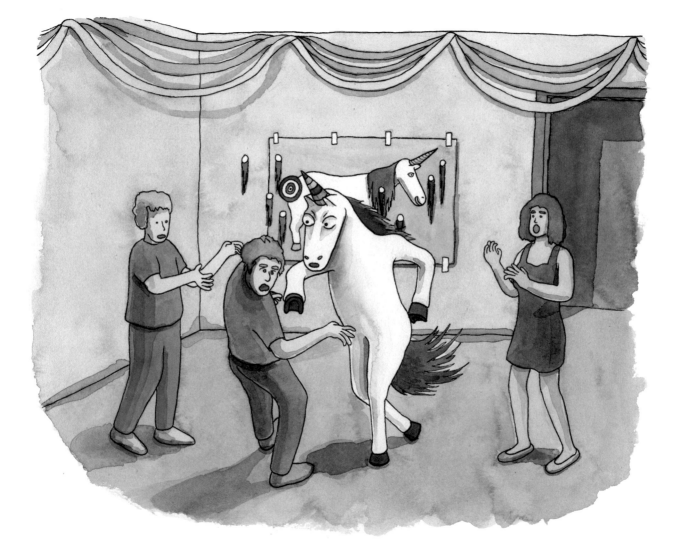

His kids don't understand what makes them special.

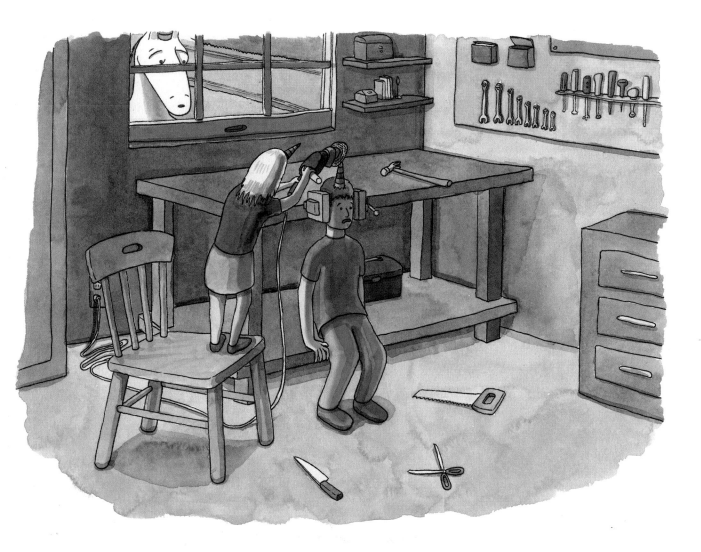

...but he is starting to think they may have a point.

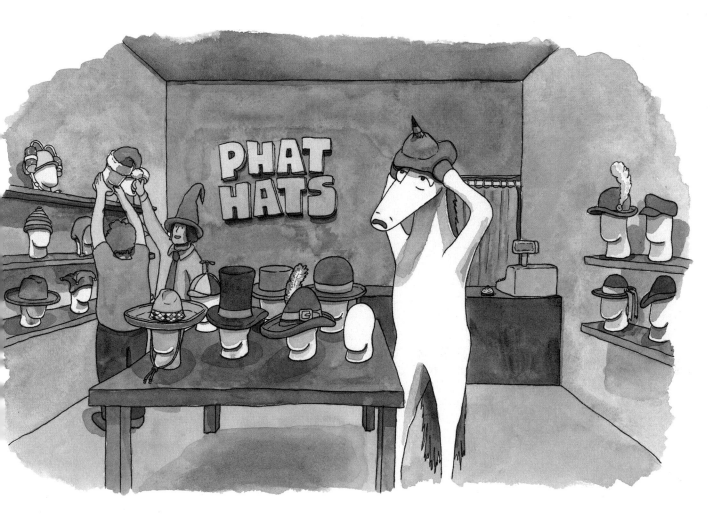

The only thing his diploma got him was a lifetime of debt.

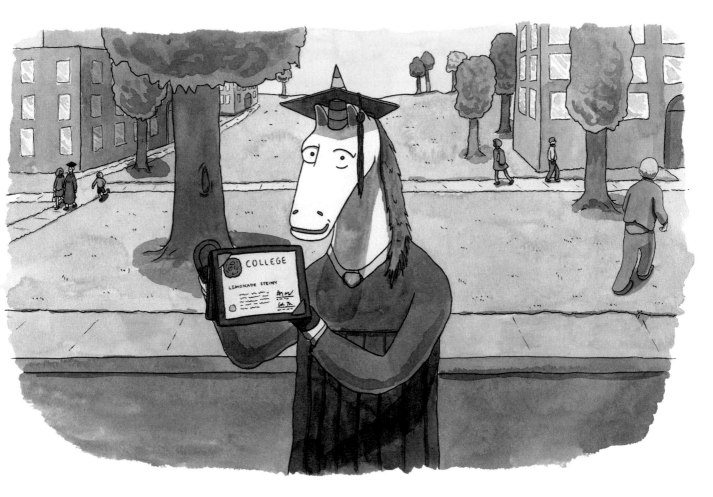

He lost the unicorn look-a-like contest.

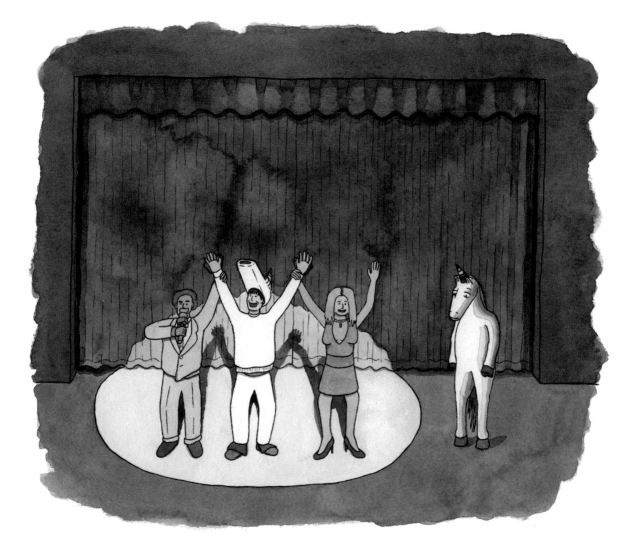

He didn't have the heart to be a serial killer.

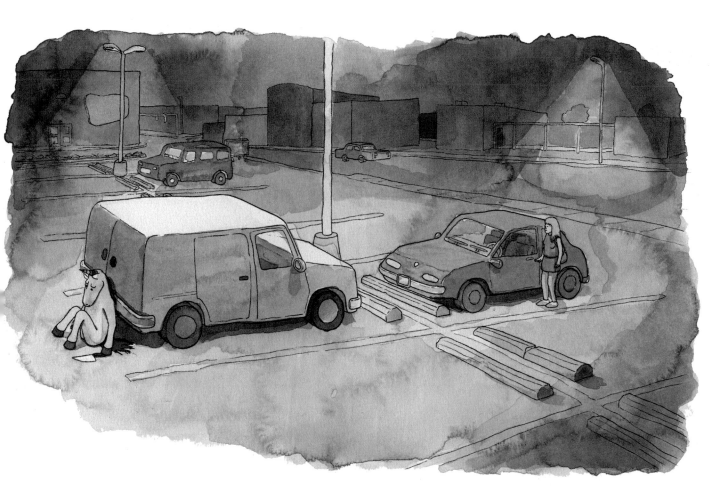

None of his dates really look like their dating profile picture.

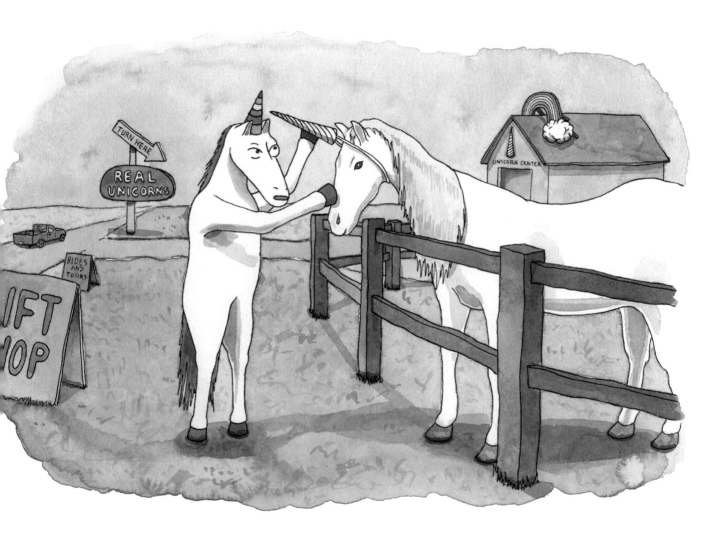

He couldn't trust stereotypes anymore after seeing the darker-complected gentleman had a baby dick.

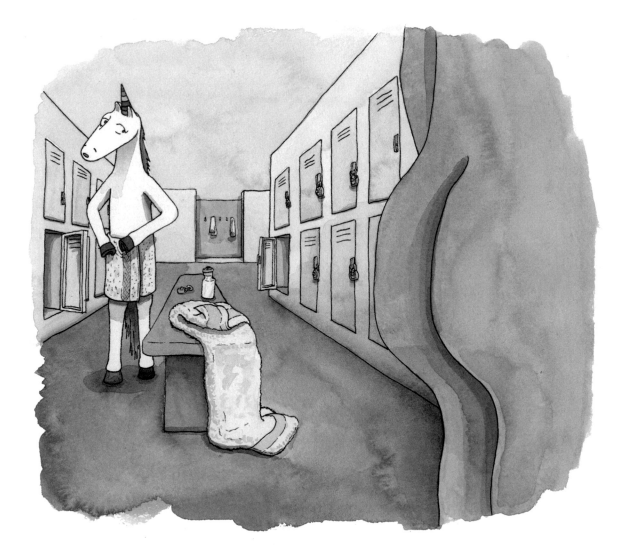

He thought it was cupid. She thought it was vodka.

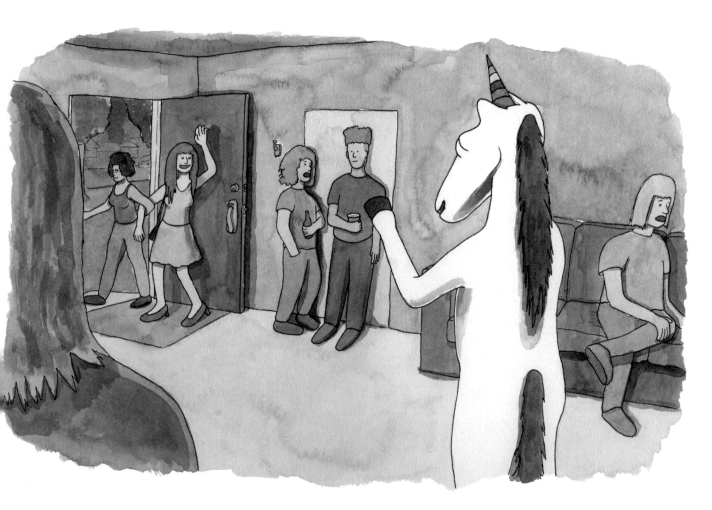

The hobo he "put out of his misery" had an extra bottle.

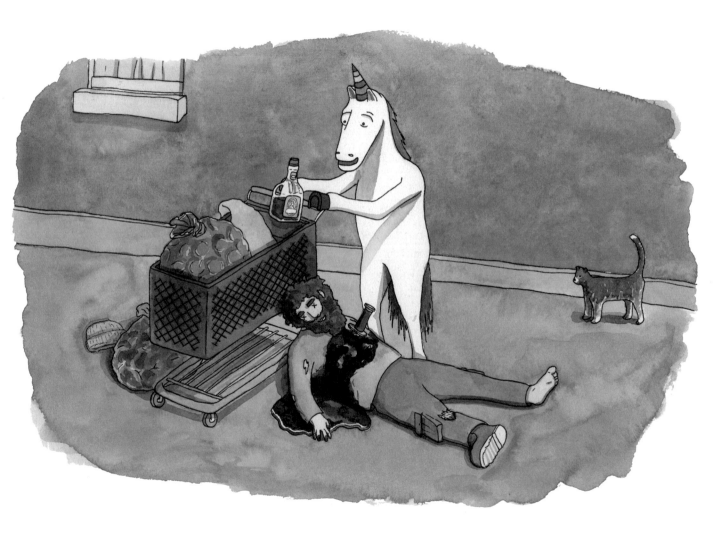

"Whiskey dick" doesn't belittle him the same way erectile dysfunction does.

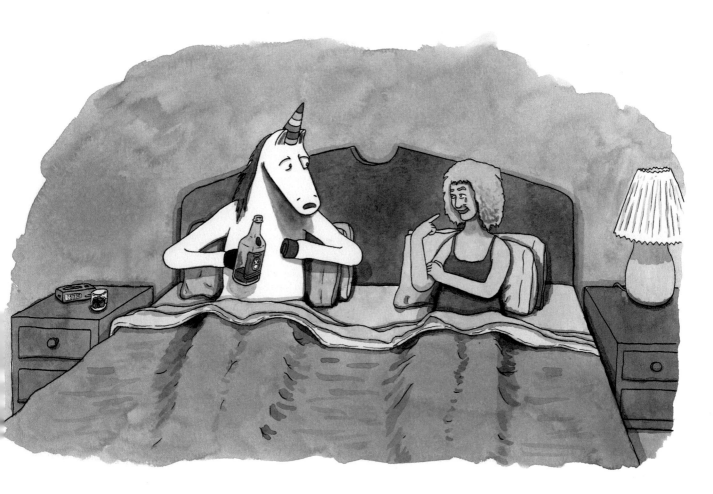

Unicorn meat is a delicacy in every country he wants to visit.

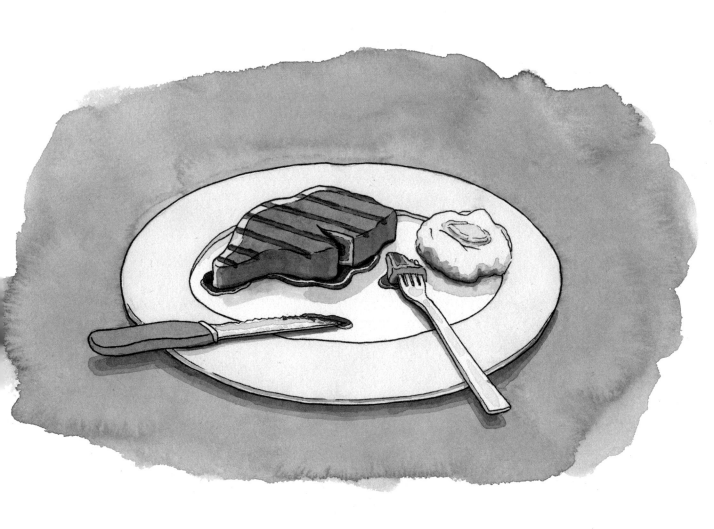

Training for a full year just wasn't enough.

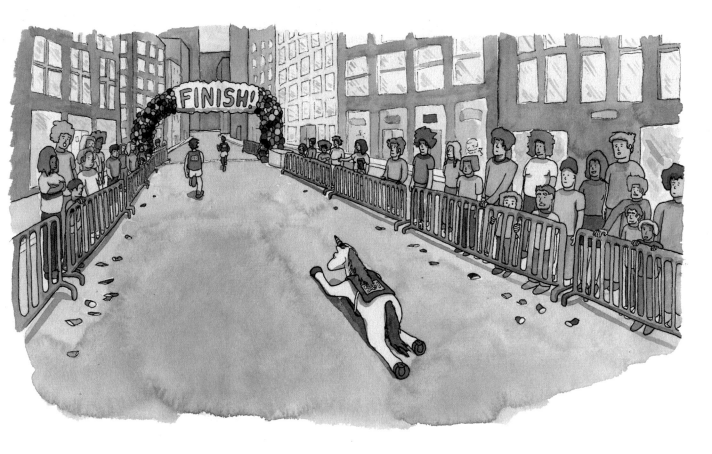

He is going bald.

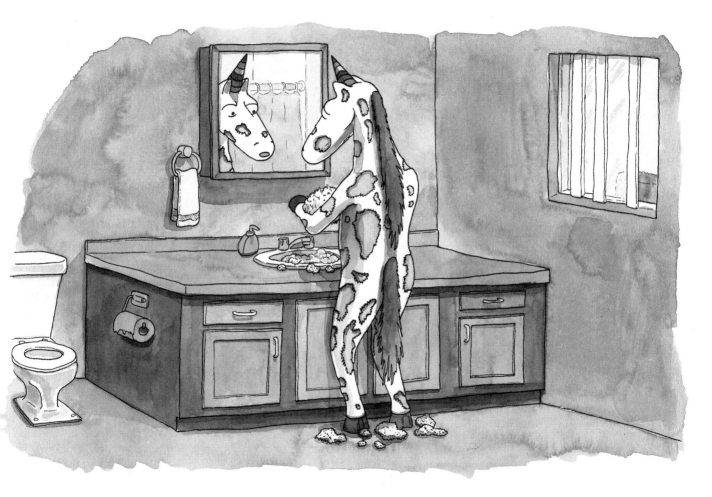

People keep asking his wife if they can buy him.

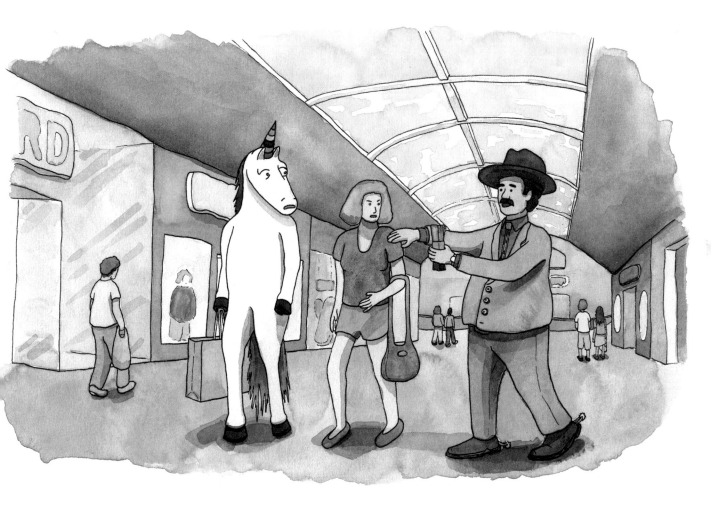

His daughter is showing early signs
of being a slutty whore.

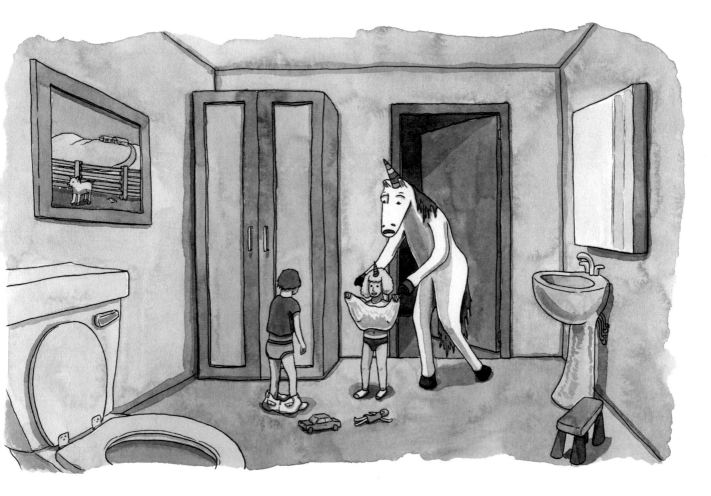

He couldn't see the cake through the candles.

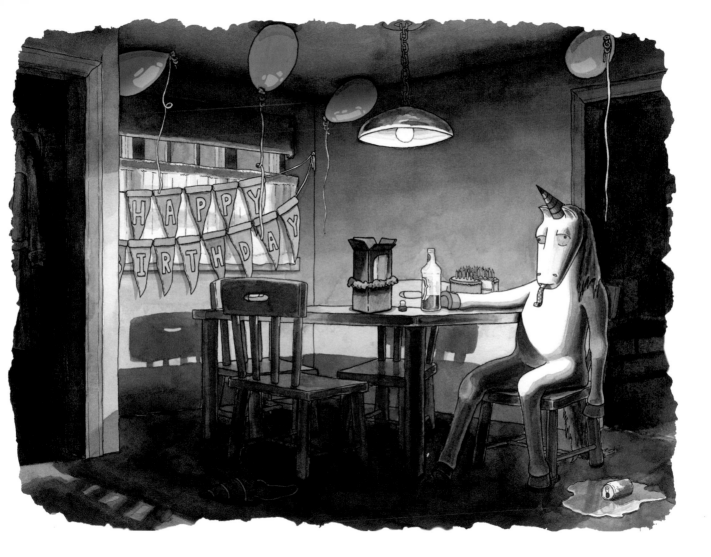

He couldn't afford to have a midlife crisis.

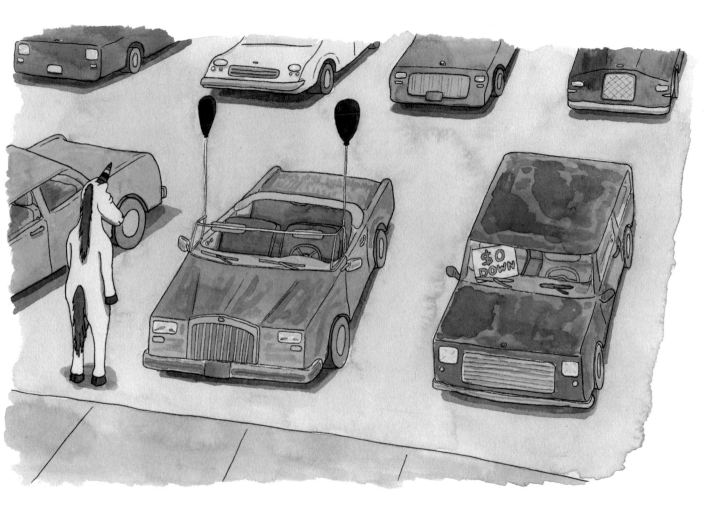

H-O-R-S-_

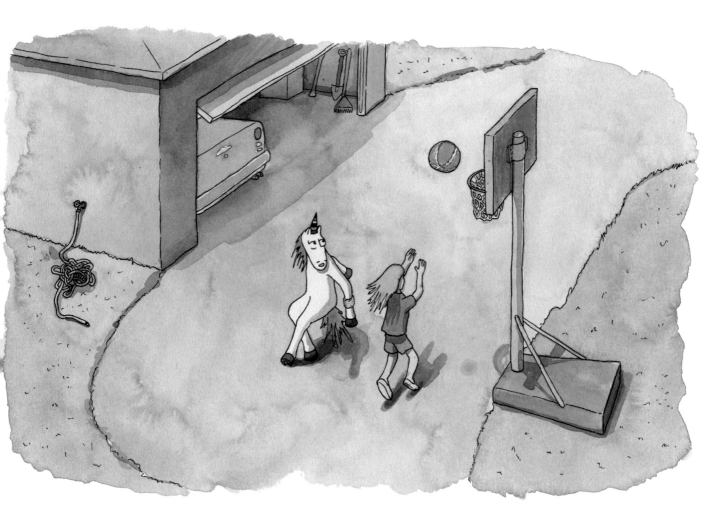

Everyone thinks he is an abstract painter.

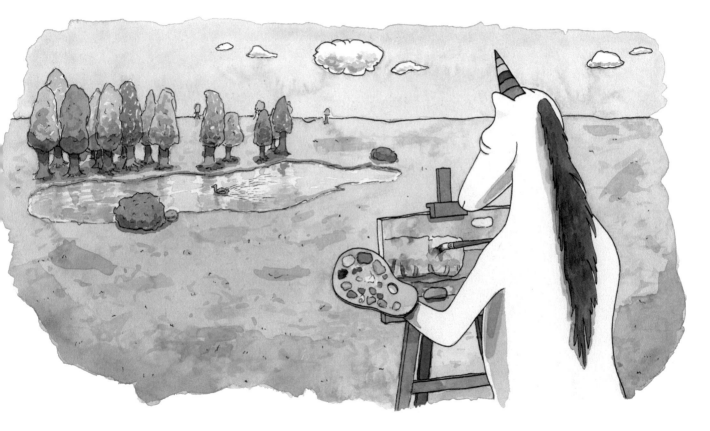

His sunburn hurts so bad.

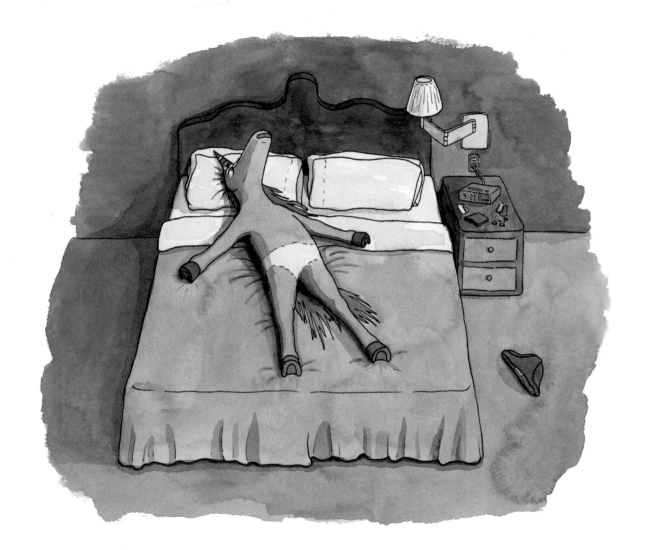

He accidentally started the landslide that killed seven families, including one that had adopted two orphans, another that had a special needs child, one with a war veteran of three tours, and the last had some kids who play on their cell phones all day.

He didn't care about those last kids though.

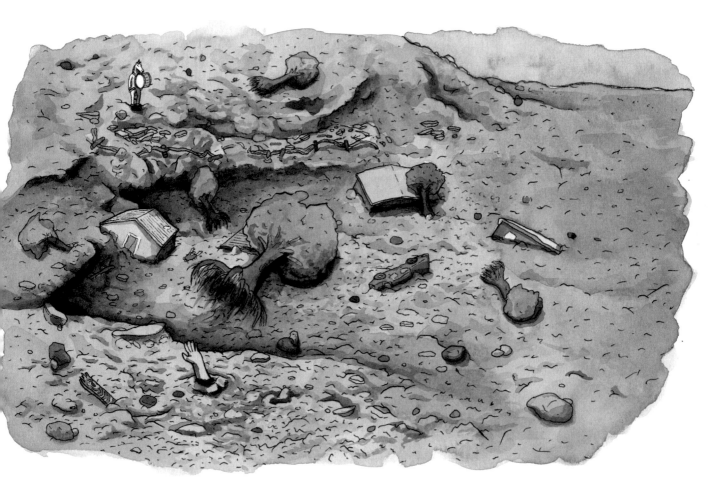

She won't let him go bareback.

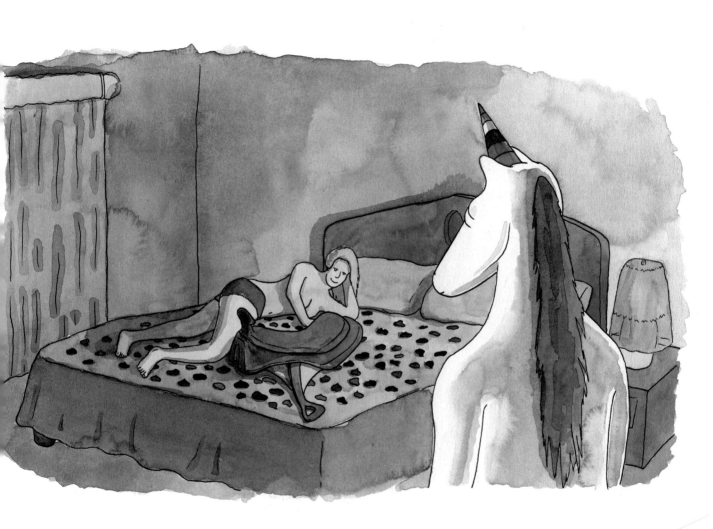

...but his uncle sure as shit didn't mind.

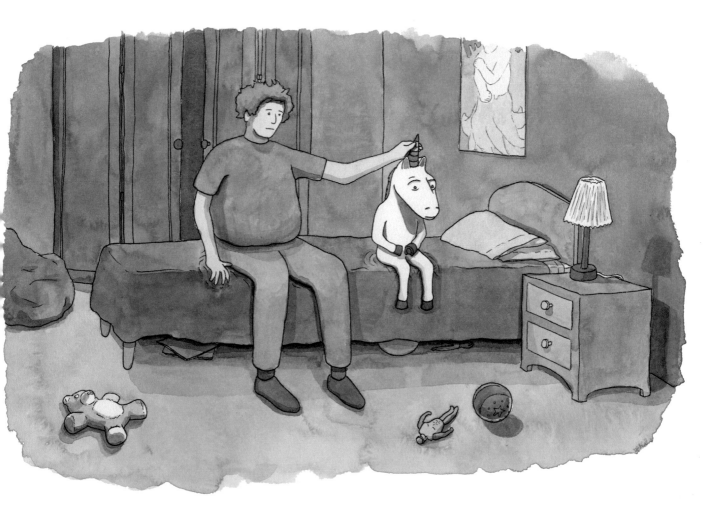

If his horn falls off, people won't care anymore.

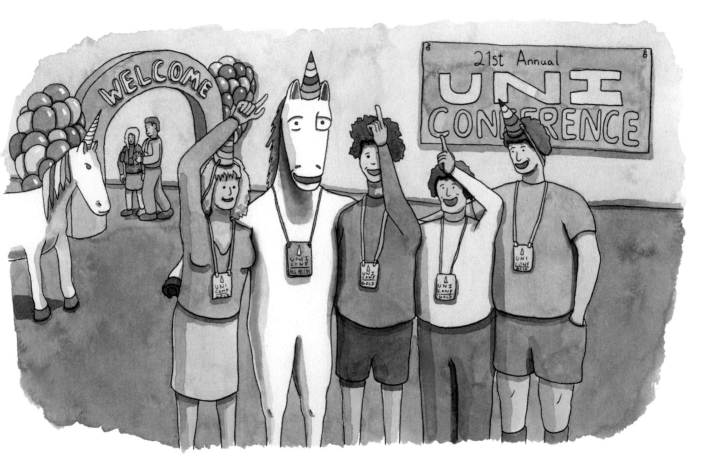

He passed away for 14 minutes and found out he was going to hell.

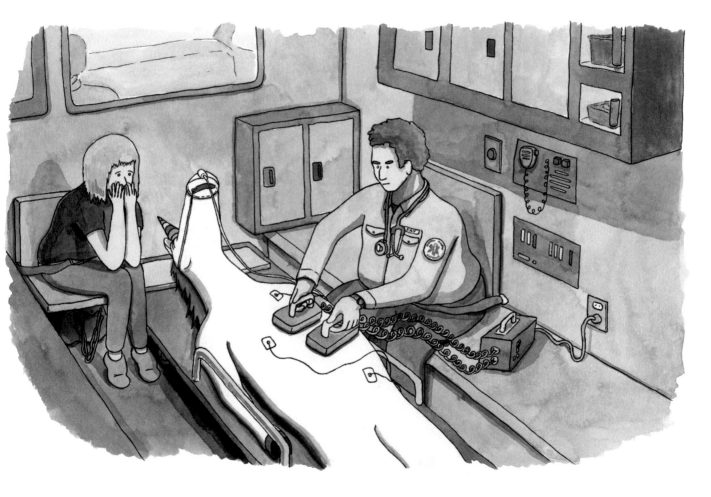

The homeless person on the bus "honk honk"-ed his penis.

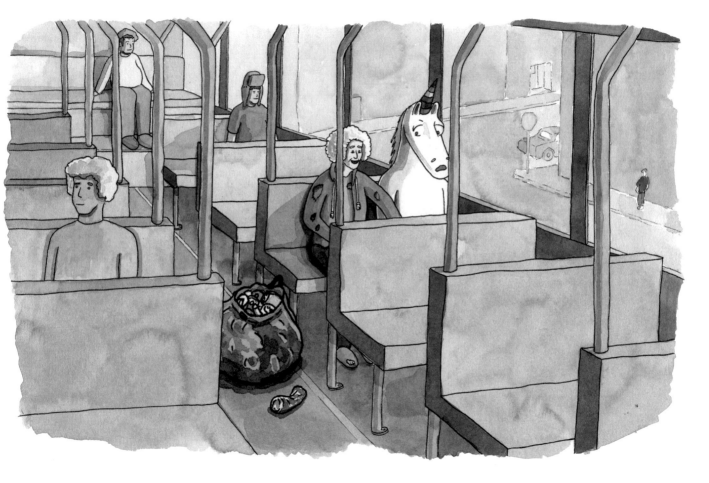

Furries keep confusing him for one of their own.

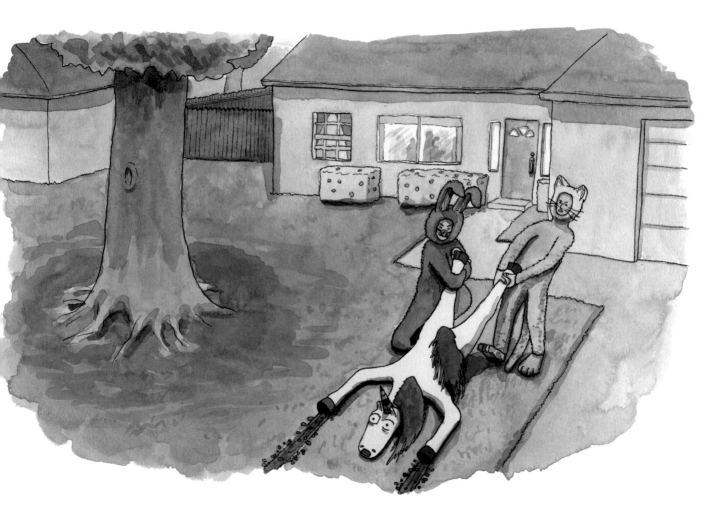

His friend tricked him into eating a placenta.

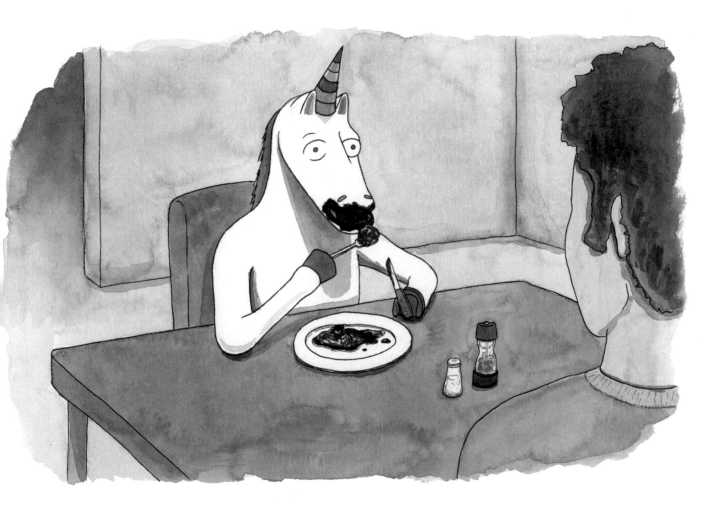

He always sings flat.

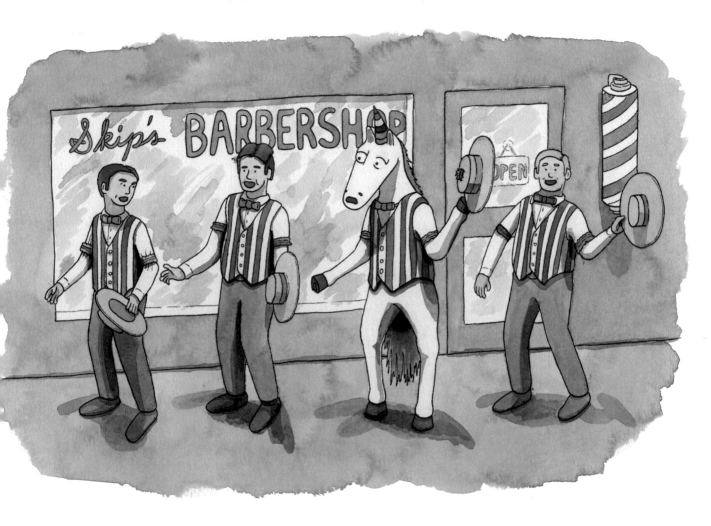

Even the blind chick thought he was ugly.

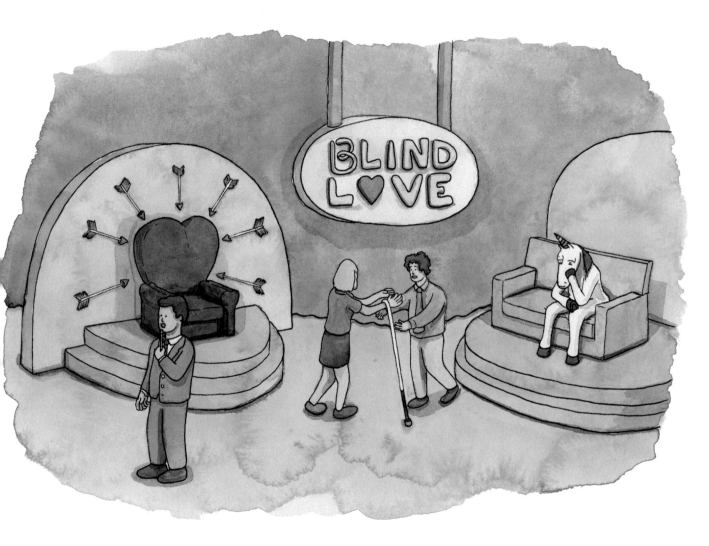

He forgot how to write the cursive 'Q'.

His hairdresser cut his hair *all* wrong.

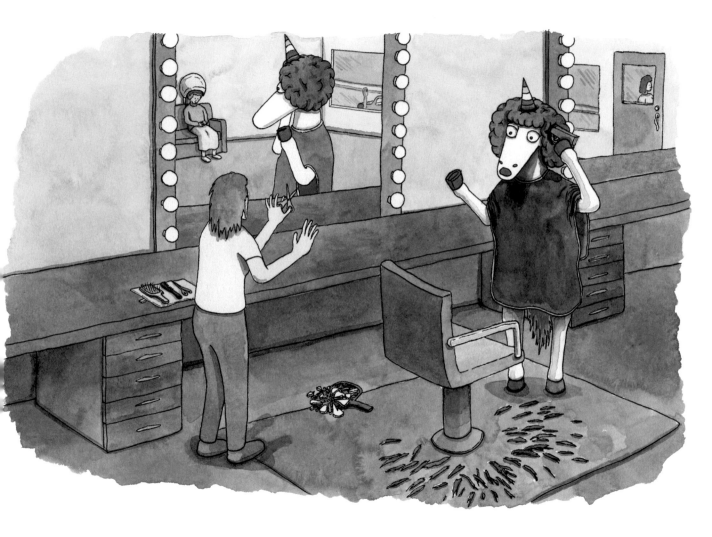

Since dad never cried, neither should he.

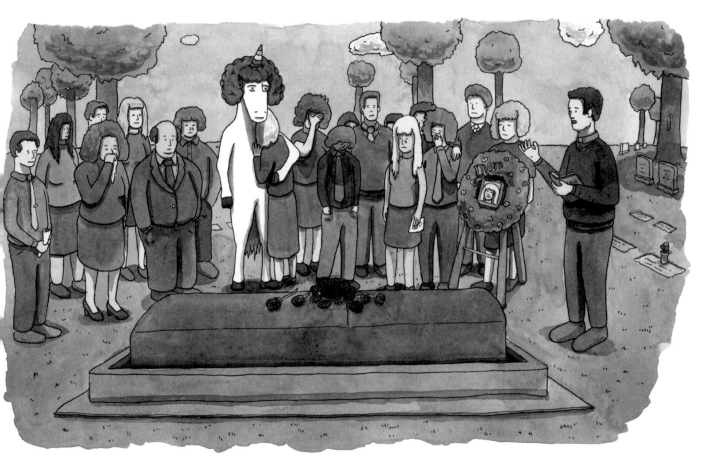

Someone always has it out for him.

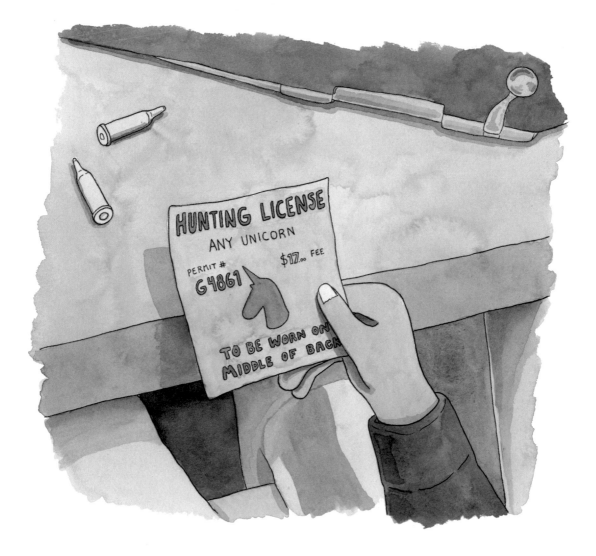

His business went bust.

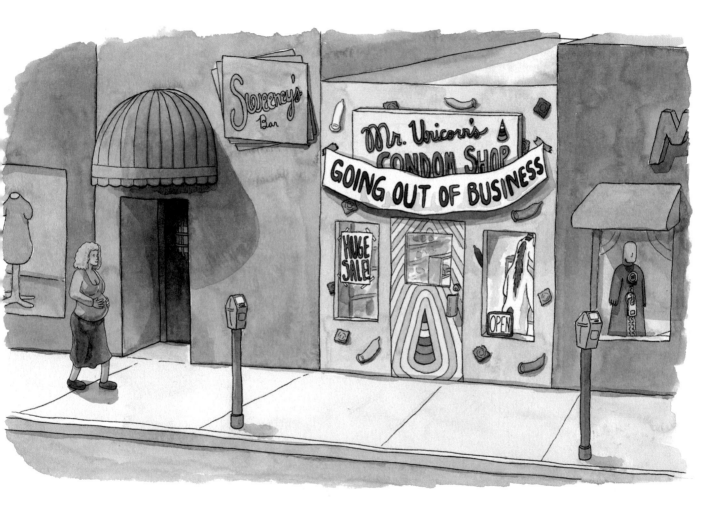

He accidentally bought a girl Harley®.

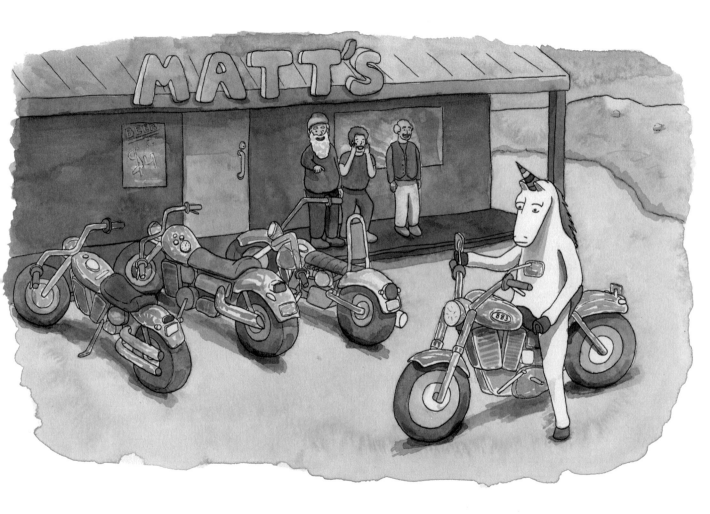

He turned out exactly like his parents.

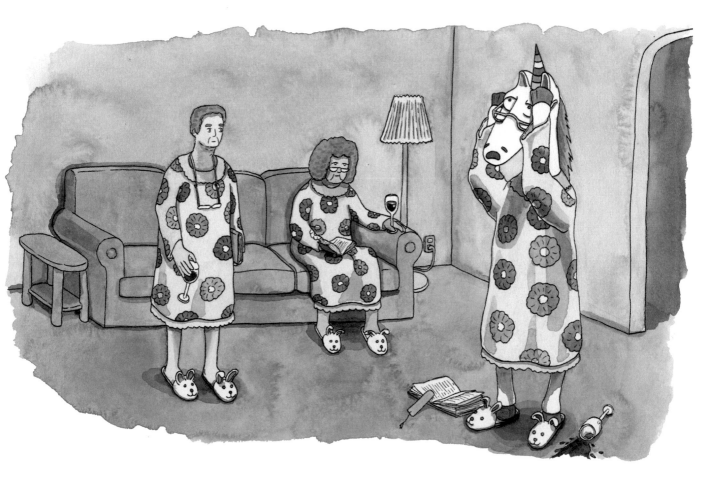

Material objects are the only way to her heart.

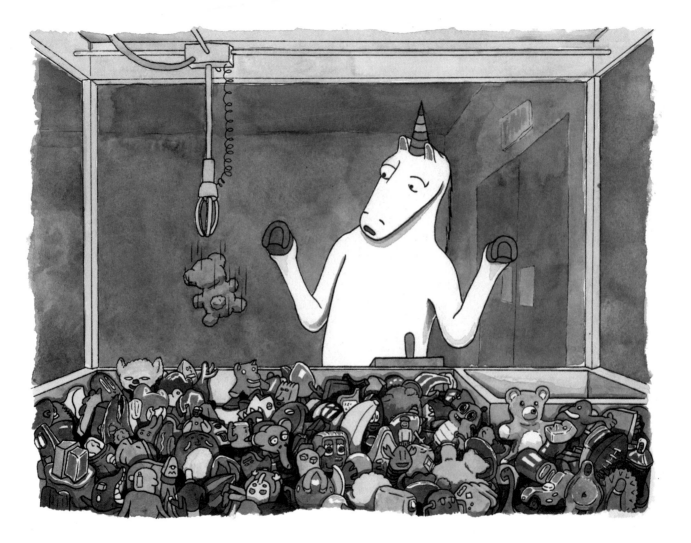

Storing his change rectally has its downsides.

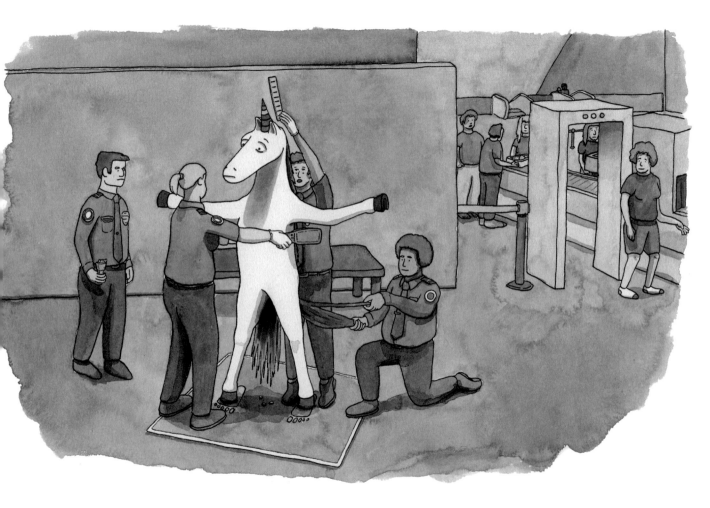

Putting in overtime didn't pay off.

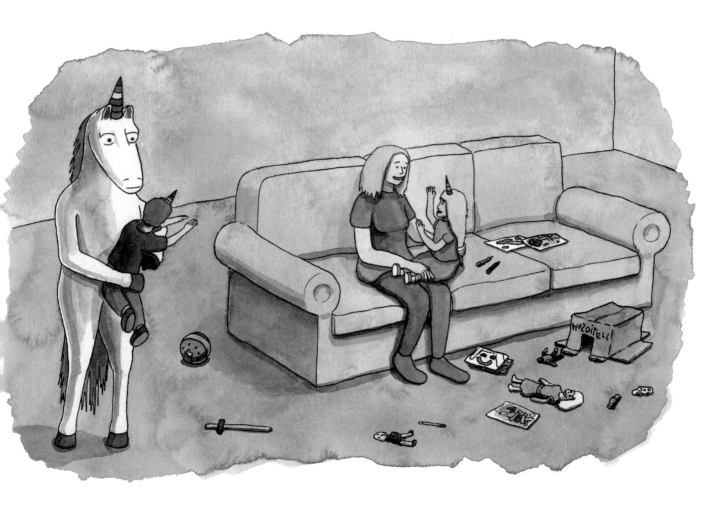

He thinks they cast his horn too small.

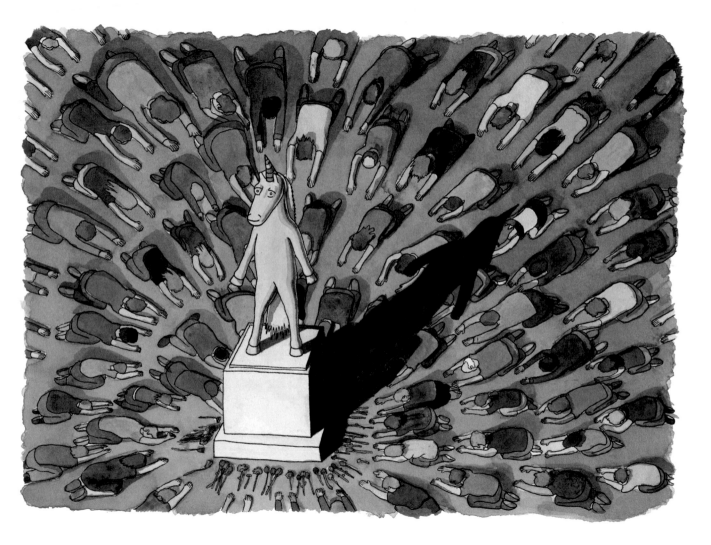

He was born on the same day as the popular kid.

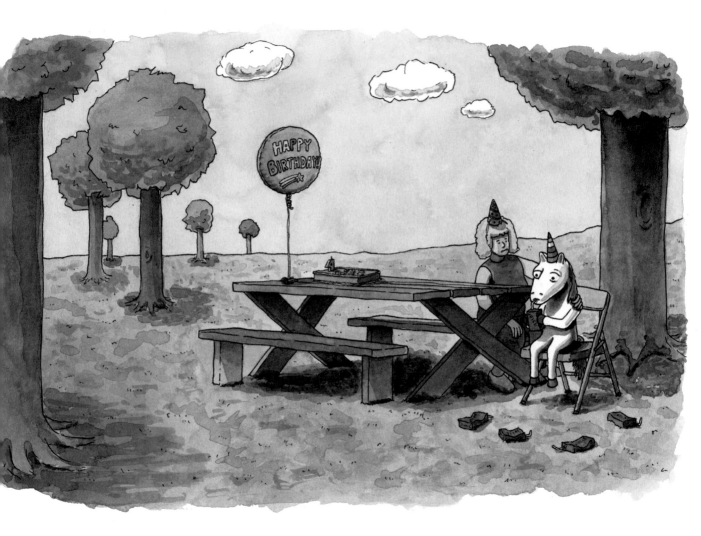

He couldn't snap.

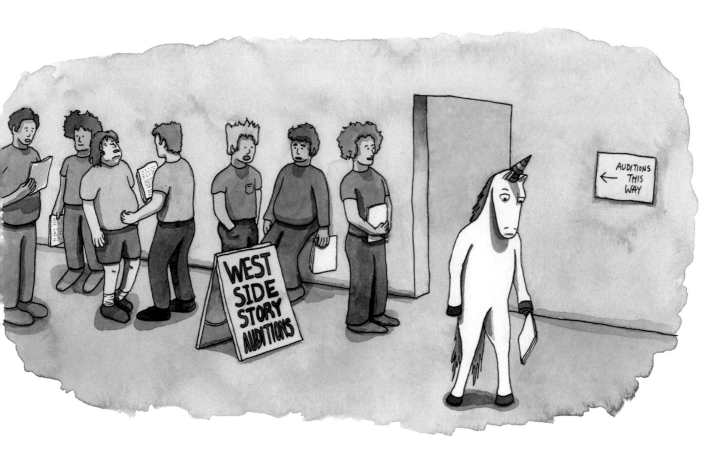

Her note said she couldn't handle
the drinking anymore.

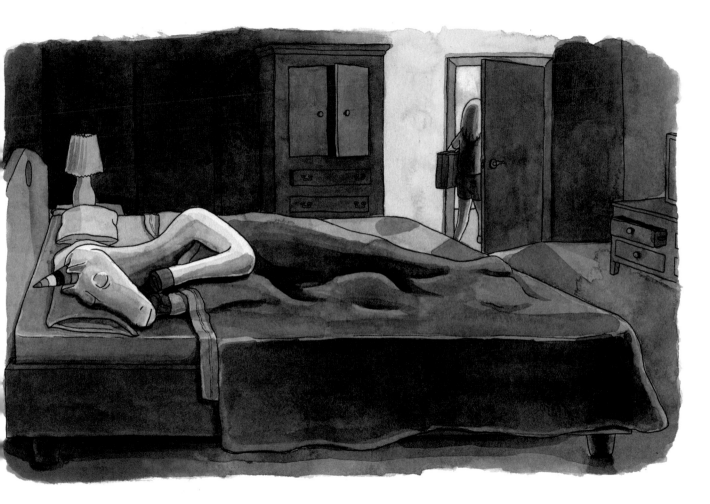

The end.

Why Unicorn Drinks wouldn't be what it is without Adam Murphy, Sam Tanis, Kate Gnetetsky, and Josh Engel. Thank you all for every bit of yourselves you have selflessly given and shared. This book wouldn't be the same without your thoughtful feedback and wondering minds. Thank you. Thank you. Thank you.

Cody, Paul, Michelle, George, Aaron, Gianna, James, and Izzy have all played a part too. Thanks, good people.

C.W. Moss would like to thank Computers Club for allowing their logo and name to adorn the arcade machine, and Laura Brothers for allowing reproduction of her incredible work titled "UEQUAL MOTIONS B" in the image that accompanies "He had a bad dream where he clicked a link on the internet, and somehow ended up dead in outerspace."

it **books**

WHY UNICORN DRINKS.

HarperCollins books may be purchased for educational, business, or sales promotional use. For information please write: Special Markets Department, HarperCollins Publishers, 10 East 53rd Street, New York, NY 10022.

FIRST EDITION

Designed by C.W. Moss

Edited by Jennifer Schuster

Library of Congress Cataloging-in-Publication Data available upon request.

ISBN 978-0-06-222713-3

13 14 15 16 17 RRD 10 9 8 7 6 5 4 3 2 1

For all questions, comments, and inqueries: drunk@misterunicorn.com

Unicorn: misterunicorn.com

C.W. Moss: greyrainbow.com